| 13 | KODAK 5063 TX | 14 | KODAK 5063 TX | 15 | KODAK 5063 TX | 16 | KODAK 5063 TX | 17 | KOD |

| 13 | 13A | 14 | 14A | 15 | 15A | 16 | 16A | 17 |

How to Photograph

YOUR BABY'S FIRST YEAR

Laurie White Hayball
and David Hayball

AMHERST MEDIA, INC. ■ BUFFALO, NY

ABOUT THE AUTHORS

LAURIE WHITE HAYBALL is a graduate of the UCLA School of Fine Arts in Motion Picture and Television. Trained as a cinematographer, she has filmed videos for MTV, as well as educational films, commercials, and dramatic shorts. Laurie was the director of photography for the independently produced film *cache*, which was selected for the 1999 Sundance Film Festival. She is also the author of *Infrared Photography Handbook* and *Advanced Infrared Photography Handbook*, both from Amherst Media®.

DAVID HAYBALL is a graduate of the University of Houston School of Communication and has worked for over twenty years in features, commercials, television, and documentaries in the US and abroad. He was the director of photography for the feature films *The Wannabees* and *To Catch a Tiger*, and photographed a dozen music videos for Ego Productions. He now works as a chief lighting technician for television and director of photography for short films. Additionally, his poetry has been featured in several national anthologies.

Copyright © 2003 by Laurie White Hayball and David Hayball.
All rights reserved.

Published by:
Amherst Media, Inc.
P.O. Box 586
Buffalo, N.Y. 14226
Fax: 716-874-4508
www.AmherstMedia.com

Publisher: Craig Alesse
Senior Editor/Production Manager: Michelle Perkins
Assistant Editor: Barbara A. Lynch-Johnt

ISBN: 1-58428-105-7
Library of Congress Card Catalog Number: 2002113015

Printed in Korea.
10 9 8 7 6 5 4 3 2 1

You probably spent the past nine months reading books and articles about pregnancy, birth, and caring for an infant. What you might not have thought about is how to take pictures of your baby that capture his or her achievements and adventures. We hope to inspire you—to become your baby's best photographer, to learn about his/her attributes and personality and to give you the tools to capture them on film.

★ A PRACTICAL GUIDE

This book is a practical guide for those of us living in a culture that is rich in technology but starved for time. In it, you will find visual recipes to feed your imagination. All you need to do is follow a few simple steps to create each portrait—and you can make every portrait, or select individual ones that particularly appeal to you. We have not used any professional tools that will be difficult or costly for you to obtain; in fact, every photo in this book can be reproduced with just a basic camera and flash.

★ ABOUT THE MODEL

You will note that all the photos in this book are of the same baby. This is our daughter, Honor. We believe it will be more helpful to you to see the same baby in many different types of photos than to show you examples of photos that might work for one baby's look and not another.

★ WORTH A THOUSAND WORDS

They say a picture is worth a thousand words—that's why there are more pictures here than words. People who take pictures like to look at pictures that show them how to make successful photos. So let's get started documenting the first year of your baby's life!

In order to start taking pictures of your baby, you will need a simple kit of photographic tools: a camera and a flash. A tripod can be useful, but is optional. The camera can be a point & shoot model with a built-in flash, a digital camera with a built-in flash, or a 35mm camera with a separate flash unit. Good photos can also be taken with disposable cameras, believe it or not. Keep in mind, the pictures aren't in the camera when you buy it. It's all the other decisions you make that will determine how your photos turn out.

★ CHOOSING A CAMERA

If you already own a camera, go ahead and use it. If you are buying a new camera, consider purchasing one with interchangeable lenses . This will give you the most flexibility in your photography. And don't worry—they are available in totally automatic versions, so you won't have to struggle with learning all the techniques required to operate a professional camera. These are available in both 35mm and digital, although the digital ones are pretty expensive.

Point & shoot cameras are a less expensive option, and are available in several formats: 35mm, APS, and digital. If you are buying a digital camera, be sure to get at least 64MB memory (defines the number of photos you can take before downloading). The camera should also create images that are at least 2.4 megapixels in size. Otherwise you may be disappointed in the quality difference compared to film. Photos taken on film provide a lot of information that the inexpensive digital camera models cannot.

A lot of people are buying digital cameras because they like to send photos via the Internet. If you have a film camera, you can still have your photos put on a PhotoCD or use a scanner with your computer to facilitate e-mail photos.

★ CHOOSING A LENS

If you have decided to purchase a new camera, consider buying a model that has a zoom lens. A lot of small point & shoot cameras come with a 2x (24mm—48mm) or a 3x lens (35mm— 105mm). This also goes for digital cameras. Having a zoom lens multiplies the possibilities for good and fun photos because it allows you to choose between a wide-angle view and a close-up view. A portrait lens is generally considered anything from 70mm to 180mm.

If you own a 35mm camera with separate lenses, a good all-around lens is a

35–105mm zoom. It is also pretty common to have a 35mm or 50mm lens and a tele-photo zoom (70–210mm). Any of these combinations will serve you well.

★ CHOOSING A FLASH

Point & shoot cameras generally come with a flash. Be sure the camera allows you to turn off the flash and still take a photo, if you so choose. If you are purchasing a separate flash for use with a 35mm camera, select one that can be adjusted to point straight at the subject, or tilted up to point at the ceil-ing, for more flexibility.

★ BUYING FILM

When you purchase film to photograph your baby, make sure the film speed is 400 or 800. This type of film will facilitate taking good photos in a number of ways. It allows depth of field for easy focus; it provides the opportunity to shoot at a fast shutter speed, which will catch baby in action; and it will allow you to turn off your flash and take natural-light pictures indoors.

Basic Rules for Good Baby Photos

1. Always have a camera with you.
2. Get down on baby's level.
3. Get close (fill the frame).
4. Find adequate natural light and turn off your camera's flash.
5. For portraits, use a long lens (zoom in).

★ GETTING CLOSE

Ingredients
- bouncy seat
- daylight through a window

Step 1—Place baby in the bouncy seat. Set the bouncy seat near a window so there is enough light. Natural light, such as window light, is easier on the baby than the harsh and sudden bright light associated with flash. Position the seat and baby in the light that looks best. In this series of

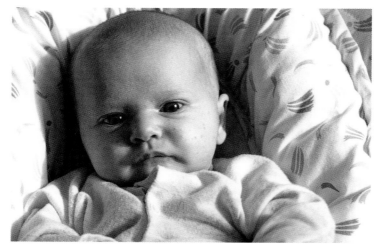

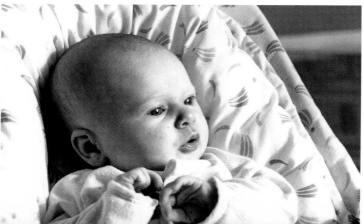

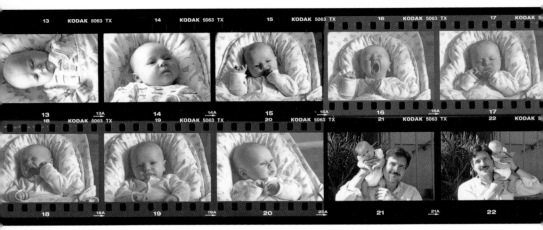

images, the window is to the right of the frame, creating shadow on the left side.

Step 2—Get down on the same level as the baby. Don't be timid; get as close as your camera will allow and still properly focus (usually 3–5 feet). Do not include the window in the picture. Fill the frame with the baby.

Tips

1. Do not include the window in the picture.

2. Start taking rolls of film, not just single pictures. Professionals do this and select their best shots.

3. Black & white film is a good choice for portraits in the first month, as babies tend to have uneven skin tone and temporary blemishes.

Step 3—Be patient. Take your time. Try to capture different expressions. Don't worry, if you miss one, another will come!

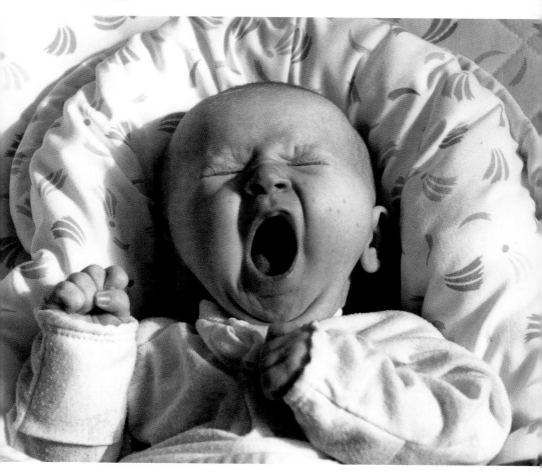

Ingredients

- hospital delivery room
- tape measure
- camera flash

Step 1—Be prepared before you go into labor. Assign the task of taking photos to someone who is going to be present at the birth. Make sure they know how to use your camera.

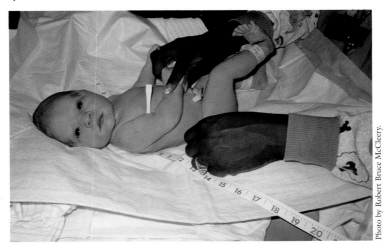

Photo by Robert Bruce McCleery.

Step 2—Don't be afraid to get in close. After the baby is born, a lot of things happen quickly. Talk to the nurses if you are unsure about whether you can take a picture.

Step 3—Watch for a moment like the one shown on the facing page and include the measuring tape in the frame. Another fun photo might be the baby on the scale with her weight in view.

Tips

1. Put someone in charge of taking photos in the delivery room. Make sure they know how to use your camera.

2. Hold the baby so we can see her face.

3. Getting the camera higher makes it easier to see both the baby and the person holding her.

Ingredients

- baby
- flowers (or a gift for baby)
- blanket
- table or floor

Step 1—For this shoot, you'll create what amounts to a still life scene with your baby. For a background, look for

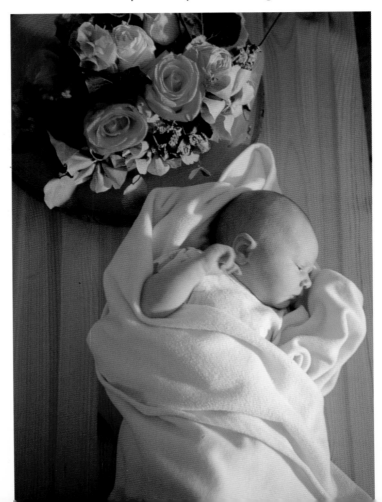

colors that will complement your baby's skin. This yellow blanket (facing page) creates a soft frame around her face and lets the flowers pop out with all their color.

Step 2—Lay the baby down on the floor near a window for light. Place the flower arrangement (or gift) close by. Compose your photo to include both. (A plush toy would also make a good accompaniment.)

Step 3—Turn your flash off. Take several photos to ensure capturing a good expression. The still life concept even allows baby to be sleeping for this portrait.

★ TO FLASH OR NOT TO FLASH

Ingredients
- bassinet or playpen
- daylight through a window

Step 1—Place baby in a bassinet or playpen near a window. Position the baby or the bassinet so that the baby's face is illuminated. If the baby is looking toward the light, the window will reflect in her eyes and create what photographers call an eyelight.

Step 2—Turn off the flash on your camera (see facing page). Lean against something to steady the camera.

Tips

1. Position the bassinet to illuminate baby's face.

2. When shooting without a flash in low-light situations (not outside in the sun), a tripod will ensure the best quality photo. However, setting up a tripod takes time that you probably don't have. Instead, when you go to take the picture, lean against something like a wall. If you are not standing, then try to put your elbows on a table or chair to steady the camera. Take a breath before you push the button and hold still until the camera stops making noise.

Step 3—Take some photos.

Variations. The photo on the left shows the exact same scenario as the one on the right, but the camera flash was used. Note how the flash overwhelmed the natural light from the window and the eyelight is entirely lost. Also, a hard shadow is created behind her head and hand causing an unappealing "cut-out" look.

★ SECURITY

Ingredients
- the arms of a loving person (Daddy, Grandma, big brother, etc.)
- window light

Step 1—When you want to take a photo, don't be afraid to try different things. Start to consider your compositions. Just because someone is holding the baby doesn't mean you have to include them in the photo.

Step 2—Use the arms of the person holding the baby as a framing device to help evoke a sense of security. Natural window light complements the mood of the composition.

Step 3—Take the picture.

Tips
1. What do you want to say with your photo? This photo communicates a sense of security. Having a message in mind can help you design photos with special meaning.
2. If your camera has a long lens, use it to get closer. Our APS camera has a zoom lens (24mm to 48mm). Zooming in to 48mm makes all the difference in this shot.

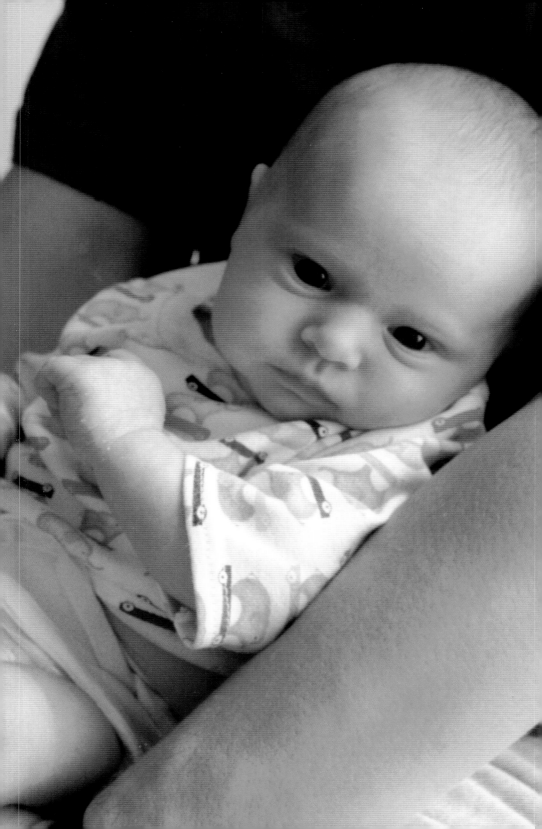

Ingredients
- bassinet or playpen
- black & white mobile

Step 1—Look at your baby's environment. What is it like to be her? What does she see? How can you show that in a photo?

Step 2—Frame your picture using foreground and background elements to tell a story.

Step 3—Take a few photos.

Tips

1. Use elements that tell a story.

2. Objects in the foreground or background of your photo can be used to frame your subject, draw the viewer's eye to specific place in the photo, and create depth and, therefore, more interest. Be aware of the other elements in the photo—not just baby—and consciously place them in the frame where they enhance the story you are telling, rather than distract from it.

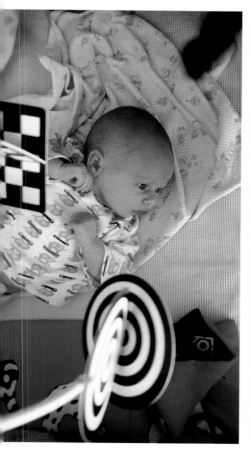
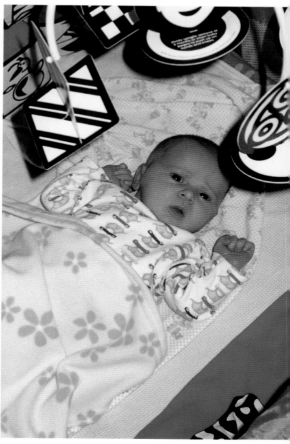

Ingredients

- baby in light-colored clothes
- a loving person in a dark shirt (Daddy, Grandma, big brother, etc.)
- shade under a tree

Step 1—Once baby is old enough to venture outdoors, look for a nice spot to sit in the shade. Pay attention to what is in the background of your photo—frame your photo to eliminate intensely bright areas that will distract from your subject.

Step 2—Position your subjects with their faces close. In this series of images, placing the baby against Daddy's dark shirt helps to define her shape and size.

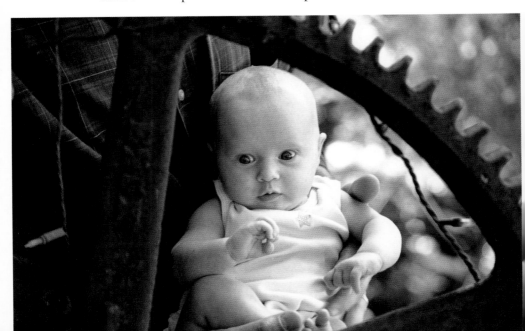

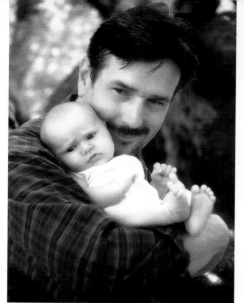 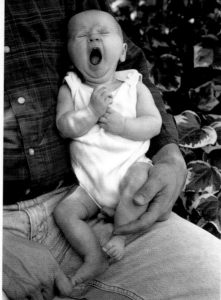

Step 3—Don't always insist on photos where everyone is looking at the camera lens. Watch for natural moments like the one above, where the baby and Daddy are both drawn to the same thing outside of the frame.

Tips

1. The sun is your friend when taking photos, because it provides so much light. However, photos of people in direct sunlight can be harsh, with dark shadows and squinting eyes. When you can, place your subjects in open shade where there is still plenty of light, but the sun is not hitting them directly.

2. Use framing devices. They can help your compositions. Opposite, the wheel draws your eye right to the baby's face. Daddy's arm helps to show the baby's size, while also intimating security (above).

Ingredients
- bouncy seat
- window light

Step 1—Around the end of your baby's first month, her perfect skin will suddenly erupt in red bumps. This is normal, but it doesn't really encourage a lot of picture taking. An easy solution is to switch to black & white film.

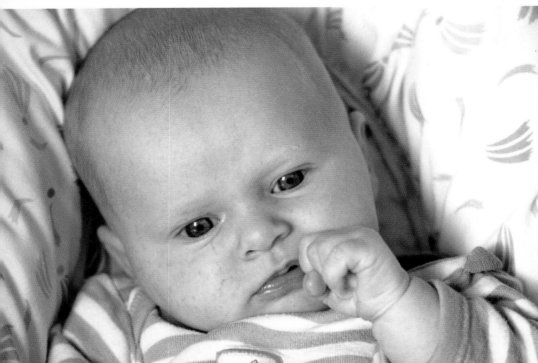

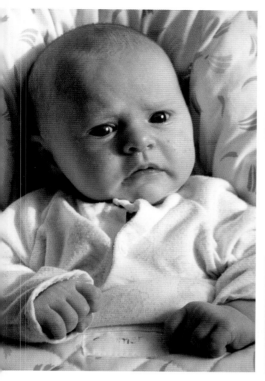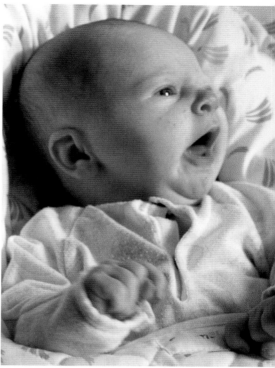

Go to your favorite window for light and set the baby in the bassinet near it.

Step 2—Facing the baby directly toward the window lights her face evenly and provides nice illumination on her eyes.

Step 3—Shoot away!

Tips

1. Black & white film paired with a soft indirect light source helps to disguise areas where baby's skin tone is uneven.

Ingredients
- sleeping baby
- window light
- optional flash

Step 1—Babies sleep away half of each and every day. If you are trying to get pictures of all the things baby does, don't forget that sleeping is one of their favorites.

Step 2—Be ready to capture both planned naps and those wonderful moments where baby slips off into dreamland without any coaxing. You might be surprised at where your baby can fall asleep. The humorous positions in

Photo by William White.

which baby sleeps can become great additions to your scrapbook.

Variations. Decide whether or not to use flash. Without the flash, the window in the photo on the facing page is overexposed but the image of baby is much prettier—especially since she is asleep. With the flash (below), the exposure is balanced inside and out, revealing more of the plane and her excitement about the adventure.

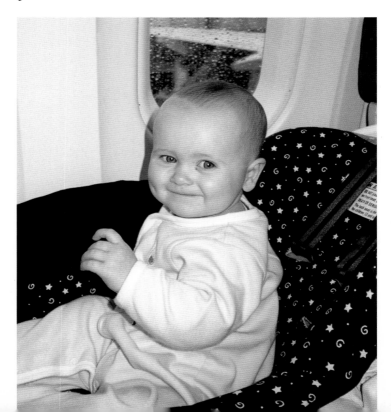

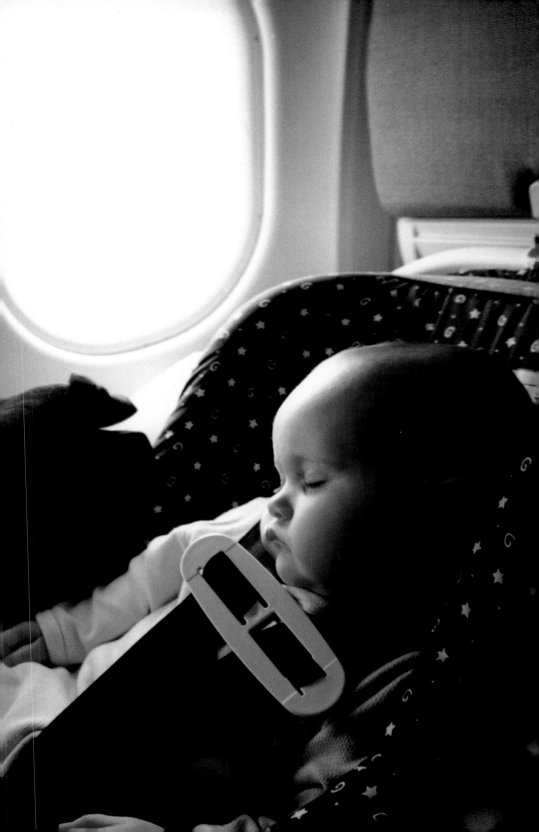

Ingredients
- happy baby
- bouncy seat or someone's lap
- flash
- helper (baby wrangler)

Step 1—Your baby now smiles, but how are you going to capture it on film? First, go to the cabinet and get out a big jar of patience.

Step 2—Ask someone to help. If your baby has an older sibling, they are usually very talented at getting baby to smile. We found that when Daddy held baby up in the air and then lowered her to his knee (facing page), she smiled every time. With that in mind, we focused the camera and

Tips

1. Patience is key in photographing baby.

2. Baby's older brother or sister can make a great assistant, drawing out baby's personality.

3. If you are trying this project alone, look through the camera and set your frame, then peek your head out from behind the camera so the baby can respond to your facial expressions.

4. One of the most difficult skills to acquire in photography is timing. Get used to your camera and the lag time between when you push the button and when the camera actually exposes the frame of film. Try to anticipate movement to capture it at just the right moment. In other words, take the picture as the smile is forming on your baby's lips, not as it is fading away.

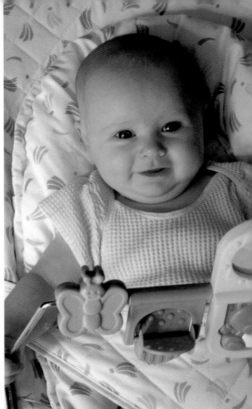

framed the photo for baby's end position on Daddy's knee. Then we waited for the smiling baby to land in the picture.

Step 3—Be prepared to take quite a few exposures in order to ensure a good one.

Variations. The photos above show flash vs. natural light. On the left, we used a point & shoot camera with the flash on. On the right, the flash was turned off. Sunlight hit the floor and bounced up to illuminate her face.

Ingredients
- morning light through the window
- wood floor creates bounce light
- flash

Step 1—Find a good place where the light through a window bounces back from the floor (light-colored wood, tile, carpet, etc.). Let baby get out on her own and explore a little.

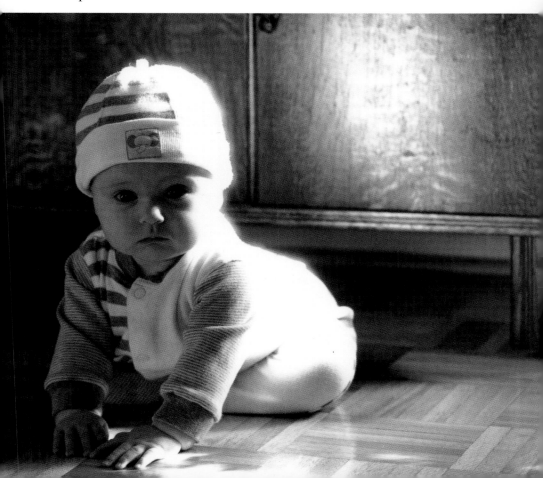

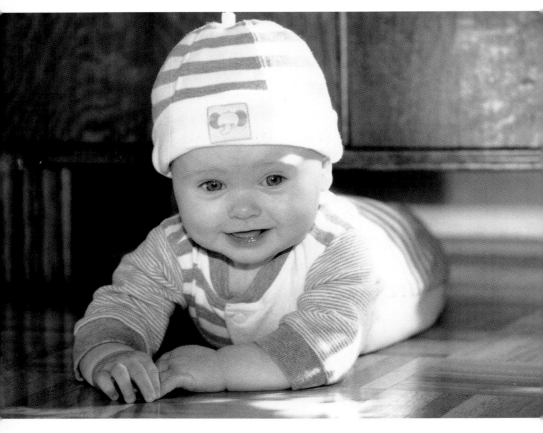

Step 2—Get down on baby's level. You want to see her eyes.

Step 3—Consider the lighting. Is there too much contrast between the background light (light coming from behind the subject) and the fill light (the light illuminating the shadow areas)? If so, you may want to use flash to put more light on the baby's face. Many cameras will

meter the average light in the frame and enable a reduced amount of flash (called "fill-flash") to even out the exposure. Some cameras are not quite so sophisticated and may try to overwhelm the sunny backlight, resulting in a flat, front-lit photo. You may need to experiment with and without the flash and remember the results for the next time you are in a similar situation.

Tips

1. Hats are very useful, especially if your baby has little or no hair. The hat acts as a framing device, drawing attention to baby's expressions.

2. Start taking notice of the light in different areas of your house. Look for areas where the sun comes into the house, or maybe bounces off a neighboring building and illuminates a room. Morning and/or afternoon light provide the most interesting light for photos.

3. Get familiar with your camera. Experiment with and without the flash and remember the results for next time.

4. If the sunlight is actually hitting the baby from behind, while also bouncing off the floor and back at her face, you probably need to use a flash to fill-in the shadow areas. "Fill-flash" simply adds enough light to the entire frame to lessen the contrast between the shadow and highlight areas of the picture, while preserving the desired lighting style.

★ SITTING UP ALONE

Ingredients
- baby sitting on her own
- window light
- zoom lens

Step 1—Sit your baby facing the window in order to light her entire face while also creating an eyelight. Place pillows behind her, as she might lean backwards without you nearby to catch her.

Step 2—Get down on the floor. The camera should be at baby's eye level, in order to see as much of those beautiful peepers as possible.

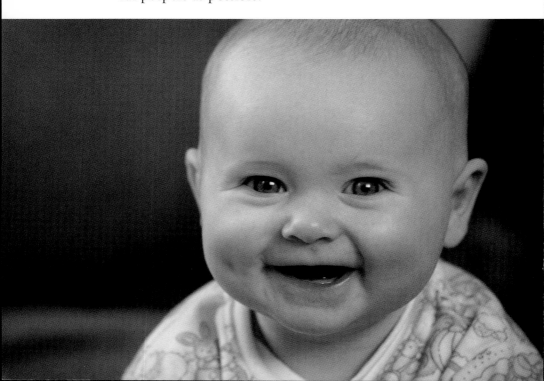

Step 3—Let your baby enjoy sitting there alone. Try to capture her different expressions as she realizes that she is doing this all by herself. The smiles in these photos were all from the excitement of her new achievement.

Variations. The photo on the left (above) was taken in the same room as the two on pages 34–35. However, now the baby is much closer to the window (about two feet away vs. six feet away). The window is above the baby and to her right, creating a shadow on her left side.

Tips

1. Once you have found some favorite photo locations in your house, experiment with different types of light. In addition to the light coming in through the window, you might use the light bouncing off a piece of furniture or a wall to the side of your baby. You might even hang a light-colored towel or sheet (warm tones are best) nearby to augment the light.

2. Notice how different looks are achieved (above, right) by changing the tones behind the baby (light vs. dark backgrounds).

★ FLOOR PLAY

Ingredients
- blanket
- ball and toys
- flash pointed at ceiling
- wide-angle lens (24mm)

Step 1—These will be the first action photos of your baby (there will be plenty of opportunity for soccer, baseball, and hockey in the coming years). Get down on the floor with your baby. Watch her play.

Step 2—Try to capture the moments of discovery about arms, legs, space, and balance.

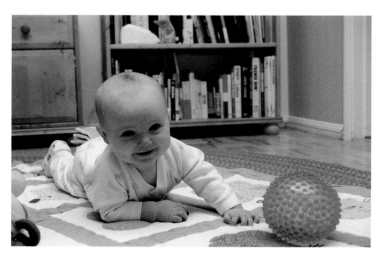

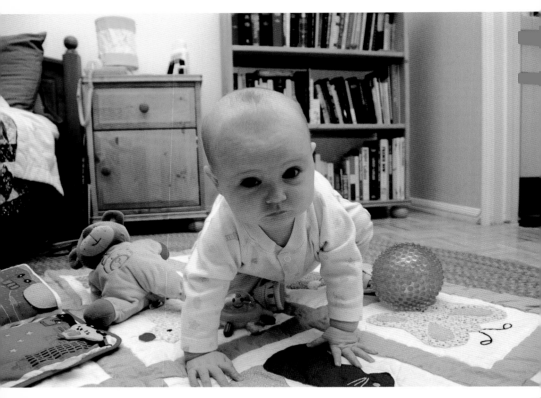

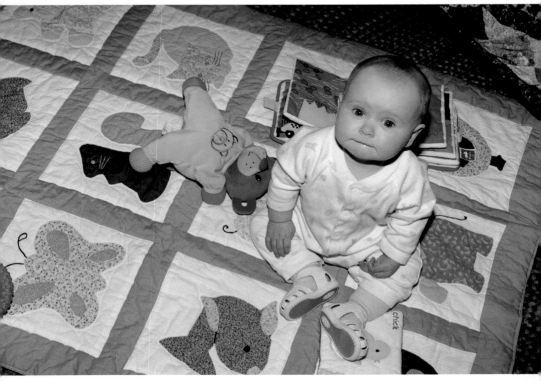

Step 3—Be patient. Use surrounding toys and your baby's position to guide your composition. Be prepared to move around a lot on the floor. Don't be afraid to try a totally different view (like from above).

Tips

1. If you have the ability to orient your flash, you can choose between direct or reflected light to illuminate the scene. Pointing the flash at the ceiling causes the light to bounce off it and reflect back down onto the subject. This type of light is referred to as an overhead "bounce light." This light is softer on the baby, and tends to illuminate the room more evenly than a flash pointed directly at the subject.

2. Never plant yourself in one spot. Be flexible; be ready to try something new. That goes for lenses, too. If you have different lenses, or a zoom, don't forget to use these as tools to include or exclude things from your photos. You are in control: capturing the moment, creating the memory.

3. The more you take photos, the more comfortable and responsive your baby will become to the camera.

Ingredients
- baby in crib
- window light and/or flash pointed at ceiling
- wide-angle lens, zoom lens

Step 1—When baby starts to pull herself up in her crib, it's time to get out the camera again.

Step 2—Use the crib or furniture that baby is clinging to in your composition in such a way as to draw the viewer's eye to the baby. This is especially important if you only have a wide-angle lens. The idea is to keep the viewer's attention on baby.

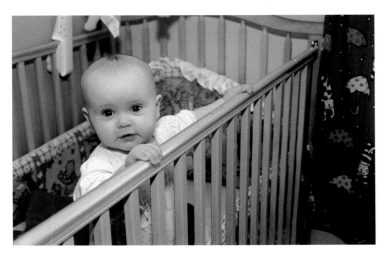

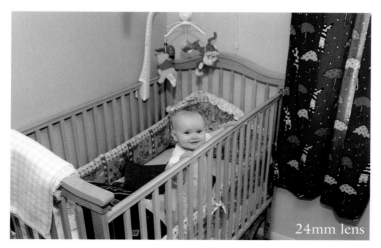

24mm lens

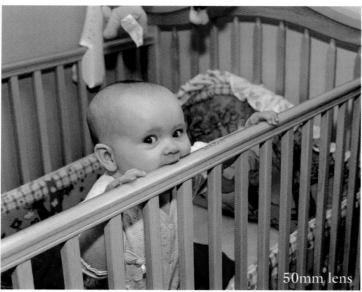

50mm lens

Step 3—As always, take a few pictures to capture the baby's different expressions of surprise, pride, exploration, and satisfaction.

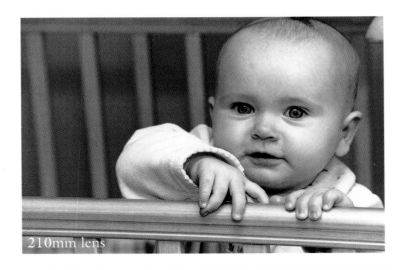

210mm lens

Tips

1. Diagonal lines can improve your composition. Placing diagonals properly in the frame will draw the viewer's eye into the photo, enhancing depth and perspective, while controlling where the viewer will look first. Be aware of even subtle diagonals and use them to your advantage.

2. Different focal-length lenses (wide-angle, telephoto) can create totally different feels in your photographs. The wide-angle (24mm) is a distorted view, exaggerating depth and showing more of the surrounding area. A 50mm lens is comparable to how our eyes see the world. Telephoto lenses (here, 210mm) are often used for portraits because they compress space and create a flattering likeness. Focus is critical with telephoto lenses, so be extra careful.

Ingredients

- crib/play area
- a favorite toy
- an interruption or surprise

Step 1—A good photo of your baby does not have to be one where she is sitting with a big smile on her face. Watch for different emotions—so many new ones emerge as the months go by. These are first-time expressions as your baby learns to use her face to express herself.

Step 2—Remember to be aware of the timing of your camera's shutter release and push that button at the right moment (as the expression is forming, not as it fades).

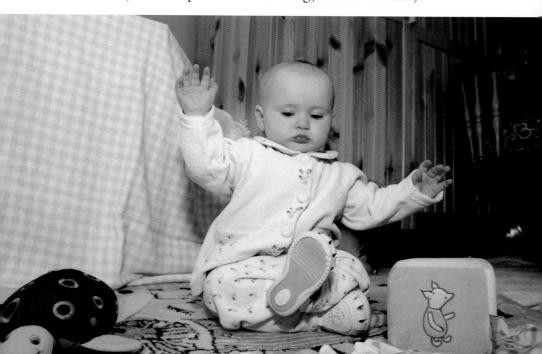

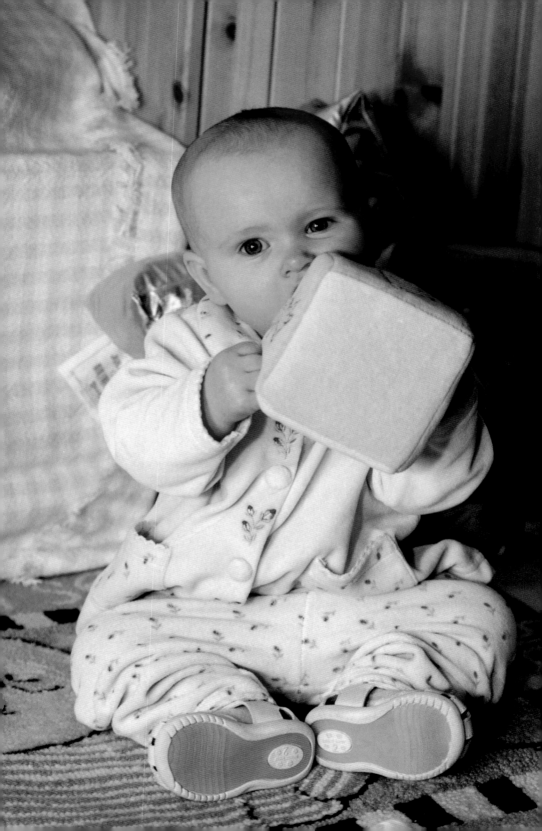

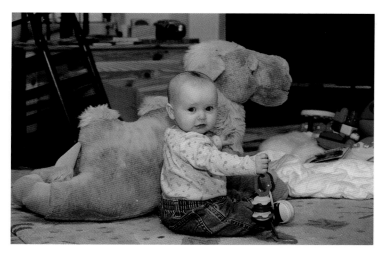

Not every photo will be perfect, so don't let that discourage you from trying to capture baby's new expressions.

Step 3—Hang out with your baby. Have your camera ready, and let her relax into her surroundings—don't try to have her perform for the camera. If you and baby are in the mood, maybe take an entire roll of pictures. You will be surprised at how many are good ones.

Tips

1. Take the photos as the expressions are forming, not as they are fading away. Get used to the timing of your camera. Does the shutter go off exactly when you push the button? Is there a delay? Does using the red-eye reduction setting on your flash cause a delay?

★ REACHING, CRAWLING, DRINKING . . . AND THINKING?

Ingredients
- adventurous baby
- your house
- a quiet moment

Step 1—Watch your little explorer as she starts to get around and into things. Keep your camera handy at home and when you go out. Your little one will surprise you with her newfound abilities.

Step 2—Try to capture her achievements on film. When your baby starts to crawl, get down on the floor ahead of her and shoot. When your baby learns to drink from a

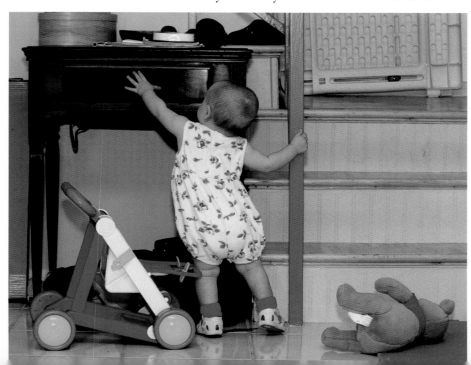

cup, get a picture of it. When your baby opens drawers and pulls everything out, document it.

Step 3—Try to take some photos without baby knowing you are doing so. These moments when they are deep inside their own heads can sometimes be more interesting than a big cheesy grin at the camera.

Variations. Always have your camera ready. Keep it loaded with film and accessible. Most great photo opportunities won't wait for you to run, find your camera, put new batteries in the flash, etc. When you see the moment, seize the moment. Your baby is becoming more and more aware of her world every day. When you find your baby quietly contemplating, try to snap off a few frames of film before she realizes you are watching.

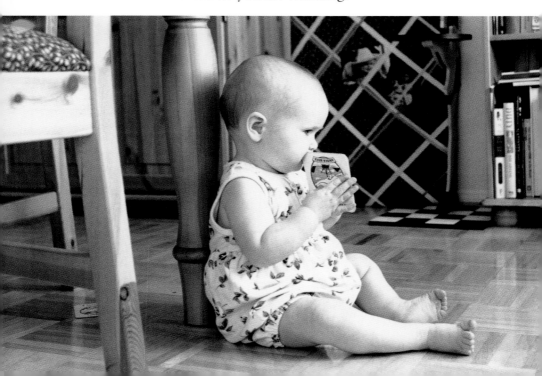

★ STANDING UP

Ingredients

- baby attempts to stand
- baby blanket to disguise unwanted elements
- pillow for accent
- baby's rug for texture

Step 1—As your baby grows more confident, pulling herself up and standing, get ready to capture her attempts to go out on her own. Suddenly, more of the world is accessible, and she will take advantage of her newfound skills.

Step 2—As always, get down low. The camera should be at the baby's eye level. This way the baby's eyes will be prominent in the photo.

Step 3—Take a few photos. It may take more than one to capture that perfect expression of self-satisfaction.

Variations. Taking photos in a series is always a fun way to tell a story. Here, she is standing so proudly, then a bit of anxiety appears on her face as she sinks down to the floor once more. Finally, she has a little chuckle at her predicament.

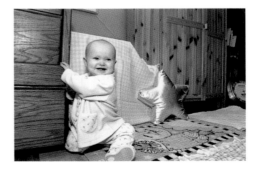

Ingredients
- hat
- shady area outside
- zoom lens

Step 1—When you feel it is time for a nice portrait of baby, go outside in your yard or to a park and find a nice shady tree to sit baby under. Try to make baby comfortable and have a helper direct her attention toward the camera. If you are alone, a noise-making toy can do the trick.

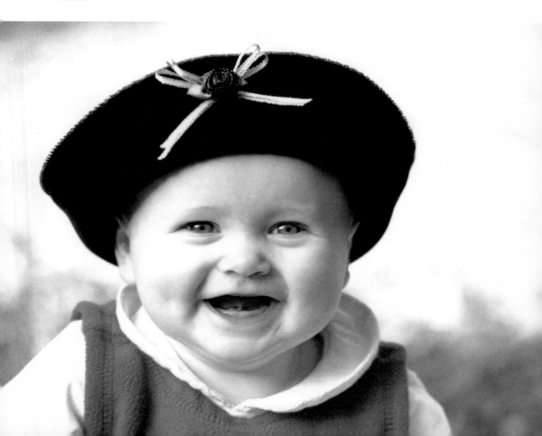

Step 2—Use a telephoto lens to frame a close-up shot of just her face. Consider the background. Is it lighter or darker than baby's face? In the photo on the previous page, the bright light behind her helps to separate her hat from the background. In this situation, be careful that you are framed tight enough that your camera will expose for the baby and not the background. (Autoexposure cameras tend to expose the center of the photo properly.)

Step 3—Watch for details like baby's hand on the arm of the chair and widen your frame to include them (below).

Tips

1. Don't rush. Hang out for a while to get baby comfortable.

2. Light and color are useful tools for good composition. Consider the dark and light areas of your frame. Look at the bright and muted colors in the scene. Move yourself or your baby to utilize the tones or colors in order to draw attention to your baby's face. The viewer's eye is immediately drawn to the place of highest contrast in the frame—where the lightest tone and the darkest tone are side by side.

Variations. Taking pictures of baby in "grown-up" adult-sized furniture (facing page) is a fun way to indicate her size and attitude. Below, the background of red roses complements her red outfit.

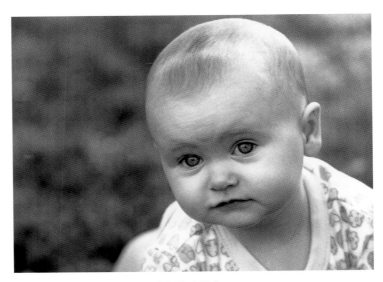

★ BLACK & WHITE PORTRAITS

Ingredients
- baby
- shady area
- zoom lens

Step 1—Black & white photography requires you to think in shades of gray instead of colors. Good photos employ separation between the tones to create a nice composition. Go outside, find a shady spot. Set baby comfortably on a blanket on the grass.

Step 2—Be aware of your lighting choices. Orient your baby so light is reflected in her eyes, and there is separation between the background tone and your baby's head. This will be different depending on your baby's hair color

(or lack of hair), eye color, etc. In these photos, the baby is sitting near the edge of the shade, with dappled sunlight occasionally hitting her head (or hat). The sunlight on the grass in front of her creates a beautiful glow in her blue eyes. The deep shade behind her separates her lighter-colored head from the background.

Step 3—Use a telephoto lens to create a different kind of separation, keeping the subject in focus and letting the background blur (opposite).

Tips

1. Blue and green eyes reflect a lot of light. Watch for this to occur naturally, and when it does, get out your camera!

2. Capturing baby's eyes on film is critical. This is achieved by making sure enough light falls on them. This can be from a flash, the sun, or a reflection of something bright (a window, cement sidewalk, a stucco wall).

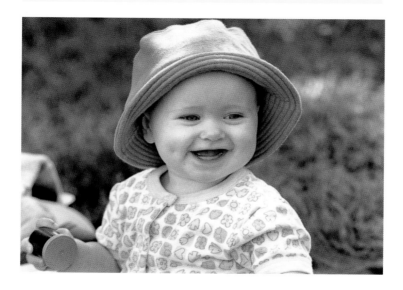

Ingredients
- good photo spot in your house
- window light
- clothes to complement the location

Step 1—Creating a pleasing photo with color film requires a lot more control over the elements in the frame than black & white film. Choose the location where you want to photograph your baby. Dress her in an outfit that will complement the color scheme and mood of the location that you selected. Try to keep the colors to two or three prominent shades. The color scheme used here was

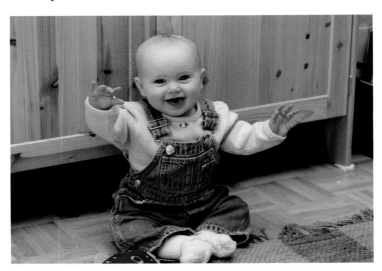

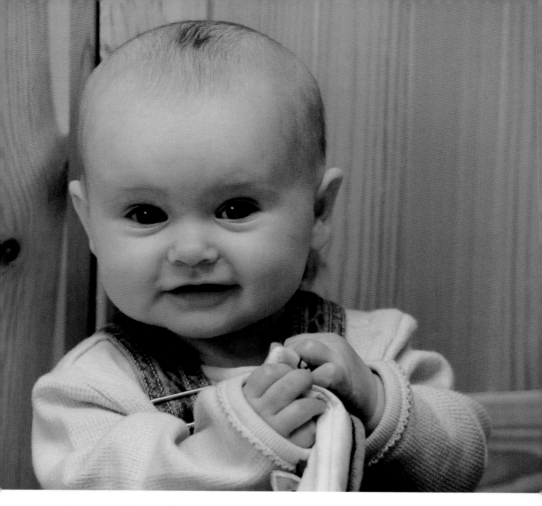

simple—blue, yellow, and pink. This simplicity helps to focus the viewer's attention on the baby.

Step 2—Have fun with your baby. Let her explore the area, and find a comfortable way to sit near you. Keep the camera ready. We sometimes sing songs, make funny faces and noises, or perform acrobatics to lighten the mood and take the focus off the camera.

Step 3—Once baby is set and in a good mood, take both wide shots that show the baby's environment and close-ups that focus on just the baby.

Tips

1. Look in any fashion magazine. The photos almost never feature more than three colors.

2. Keep it simple!

3. Have fun with your baby. Sing songs, make faces, perform acrobatics . . .

Ingredients
- french fries, crackers, ice cream
- your home, the park, or a restaurant

Step 1—Every new food your baby tries is an experience in itself. A lot of these moments can make great photo memories.

Step 2—Try to capture the discovery, the excitement, and the reactions to eating new foods.

Tips

1. Always carry a camera with you. It can be a disposable camera you leave in your purse or in the pocket of the diaper bag. How many times do you hear yourself saying, "I wish I had a camera!"?

<div style="border:1px solid">

Ingredients

- doorway bouncy swing
- flash
- fast film (see below)

</div>

Step 1—Place your baby in the doorway swing. Try to get her excited and establish a playful mood. This should not be too hard if she likes the swing.

Step 2—Set yourself up about five feet away with your camera and flash. A flash will help to capture the fast action. Use automatic settings if your camera has them. Be careful with autofocus cameras; make sure the camera is focusing on the baby and not the background.

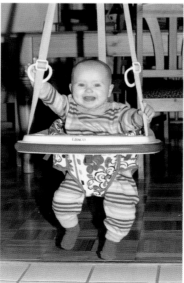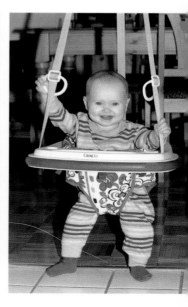

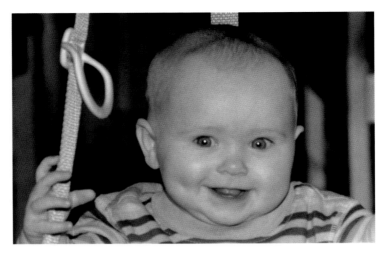

Step 3—Remember these are action photos. They won't all be perfect. Take a whole roll! Play with both wide views and close-up shots.

Tips

1. Use a fast film (ISO 400 or higher). If you can control the speed of your exposures, shoot with your camera at $\frac{1}{250}$ second or faster ($\frac{1}{500}$, $\frac{1}{1000}$, etc.) to capture the action.

2. The speed of a film (ISO) determines how much light is needed to expose it. A fast film (ISO 400, 800, 1600) lets you shoot with less light than a slow film (ISO 50 or 100). A fast film also allows you to shoot with a faster shutter speed and therefore capture action without blurring.

Ingredients
- baby and family
- beach at sunset
- sunlight from the side

Step 1—Baby's first visit to the beach is always an adventure, even if it isn't sunny and warm enough for bathing suits and sandcastles. These photos aren't so much about the beach as they are about baby's first experience with strong winds. She apparently liked the feel of the wind on her tongue.

Step 2—Position your subjects so the sunlight is falling across their faces. Mom or Dad can hold the baby, or set her up on a blanket with a beach toy. Don't put the sun directly behind the camera—you will spend too much time trying to avoid your own shadow.

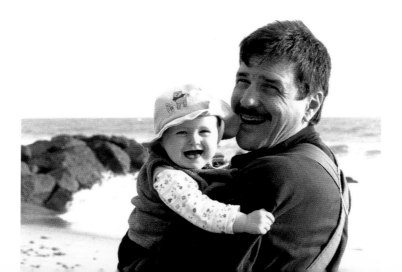

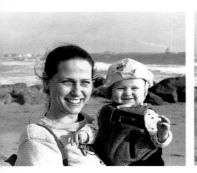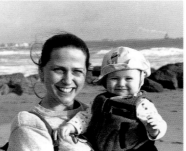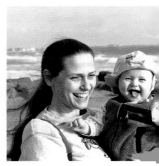

Step 3—Take several photos. Occasionally, you will end up with a nice series of expressions that are fun when framed and hung in sequence.

Tips

1. Sunset, or very late afternoon, is a good time to get photos outdoors. The sun is low in the sky and therefore creates a nice crosslight on everyone's face. In the middle of the day the sun casts heavy shadows from overhead that darken the eyes. Also, it is hard not to squint without sunglasses at mid-day. If you have to shoot in the middle of the day, find a shady tree to work under.

2. When you compose, think about all the elements in the frame. In the images above, placing the line of dark rocks at the same level as the faces leads the viewer's eye to the important part of the frame. Shooting from a higher or lower angle would not have had the same effect.

★ FAMILY MOMENTS

Ingredients
- family members
- a good book
- flash and/or window light

Step 1—Some of baby's activities are quiet moments spent with family or friends. Always be aware of potential photo opportunities.

Step 2—When you see a sweet scene like this one, try not to disturb the mood. Pull out your camera, find a good angle, choose the best lighting, and shoot away.

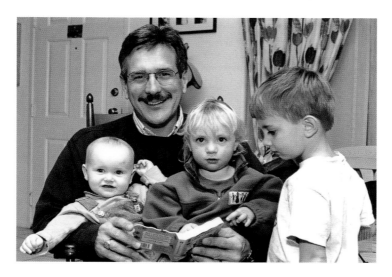

Variations. Bounce light is a very useful tool in photography. The resulting photo does not appear as harsh as one taken with a direct flash or in direct sunlight. The photo on the previous page was taken with the flash pointed up at the ceiling. The light, bounced off the ceiling, acted like a large, soft light source above the subjects.

In the photo below, there are two large windows providing light from two directions. However, there is no direct sunlight hitting the subjects, only bounce light. When there are windows available, use them as an indirect light source, but do not include them in your photo. They will overwhelm the more important elements, and may cause an automatic camera to expose the image improperly.

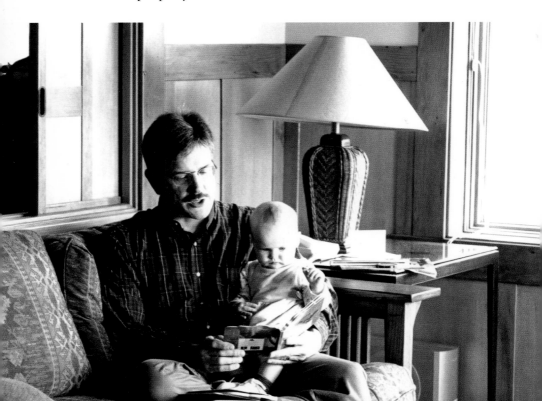

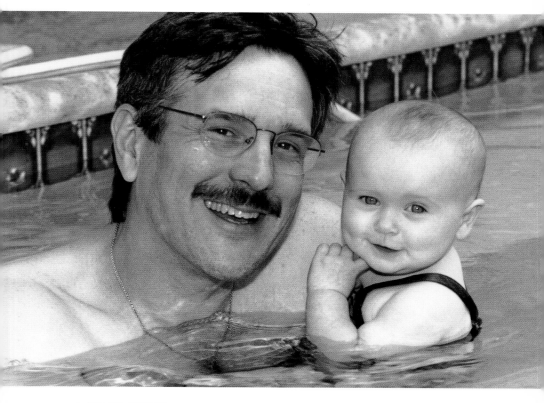

★ FIRST SWIM

Ingredients
- Daddy (or baby's swimming partner)
- pool in the shade
- zoom lens

Step 1—The first swim is a big day. If you plan to document this moment, try to go to the pool early or late in

the day when the sun is not directly on the water. Sunlight bouncing off water can be blinding.

Step 2—Get the camera down low, close to eye level. This will show more of the water in a nice close photo.

Step 3—If you have a zoom lens, try using different focal lengths to capture the experience.

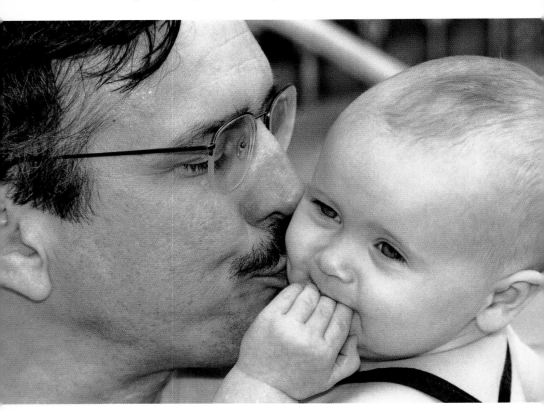

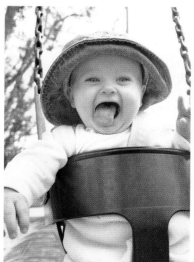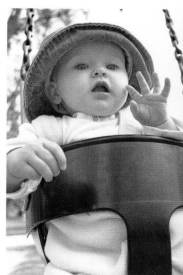

★ FUN AT THE PARK

Ingredients

- park swing
- hat
- wide-angle lens (24mm or 35mm)

Step 1—Go to the park simply with the goal of taking pictures of the baby. Put the baby in the infant swing. Play for a couple of minutes to get her in the mood.

Step 2—Kneel in front of the swing, keeping yourself at a good distance: stay close enough to fill the frame, but don't get hit!

Step 3—If you don't have an autofocus camera or if the autofocus is not working in this scenario, set the focus on your baby at her nearest position. As she swings back and forth, tilt the camera to keep her in the frame. You will see her come in and out of focus. When the focus looks good, shoot! Shoot the whole roll! (A fast [ISO 400] film also helps to increase your depth of field, which will raise the odds of getting your photos in focus.)

Tips

1. Try to find a swing and a time when the sun is not directly behind you or the baby.

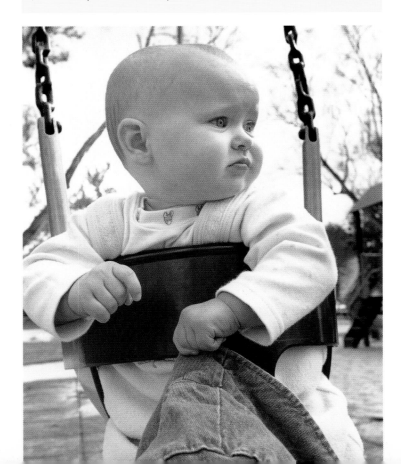

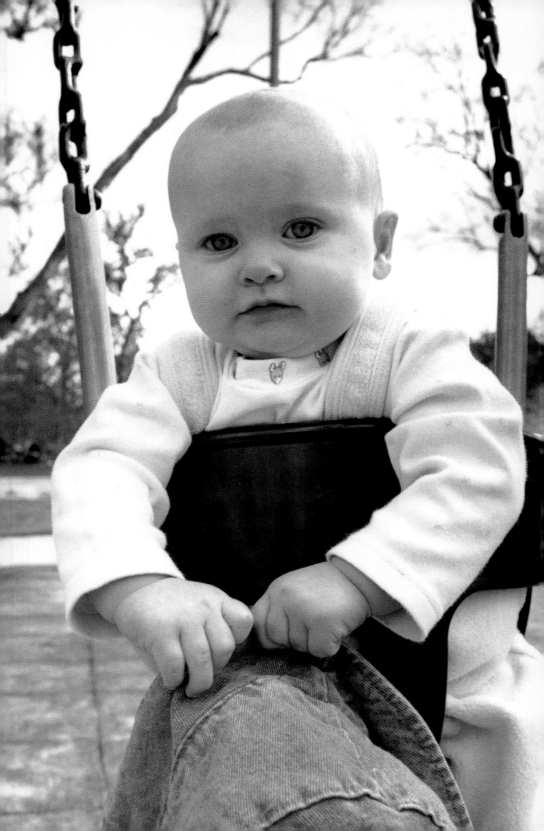

★ FAMILY REUNIONS

Ingredients
- family members
- sunlight
- fill flash

Step 1—Whenever you are getting together with family members, especially elderly ones or those who live far away, make sure you document the event. Photos will provide a lasting memory for your little one. You can also

refer to the photos when you are teaching your baby her relatives' names.

Step 2—Try to include yourself in the photo. You don't have to have a professional portrait to get a picture with the entire family, all you need is a camera with a timer. Just set everyone up and decide where you'll fit in. Set the camera on a bench, wall, etc., making sure to line up the shot as if you were already in the group. Set the camera on "timer" and push the button. Get in place and smile!

Step 3—As always, take a few of these shots. It is difficult to get a photo where everyone looks good. Remember to remind everyone to look at the camera and don't worry about what the baby is doing.

Variations. Never miss the opportunity to get a "generations" photo. You might have three, four, or even five generations you can memorialize in a photo.

Tips

1. You might consider buying a lightweight tripod to use in these situations. There are many compact ones on the market. I leave one in the trunk of my car for unexpected photo opportunities.

2. Group shots of all the children (siblings, cousins, second cousins, etc.) can be endlessly entertaining. Don't skimp on film. The interactions are priceless documents of each child's personality.

Ingredients
- baby all dressed-up
- bounce or direct flash

Step 1—On those occasions when baby dons that special outfit, take the opportunity to do a little photo session.

Step 2—Find that nice light in your house, or use a flash if necessary. Try to remove any distracting elements from the surrounding area and compose the picture to draw attention to your baby.

Step 3—Shoot away. Remember, baby doesn't always have to be smiling and looking at the camera to get a great photo of her. Capturing different expressions gives a wonderful insight into her rapidly developing mind.

Variations. The images below show the different results you will get pointing your flash directly at your baby vs. pointing it at the ceiling and lighting the baby with bounce light. When the flash is direct (right), her pupils are smaller, calling attention to her blue eyes. Also, the shape of her face is quite different in the two photos. The direct flash emphasizes her chin, while the bounce flash (left) darkens the circles under her eyes.

Ingredients

- parents/relatives
- churchyard
- reception hall
- optional flash

Step 1—Make the most of occasions when not only baby is dressed up, but the entire family is decked out in their best. Slip that camera out of your purse or pocket and get ready to capture the moment.

Step 2—Try to set up the subjects in a nice shady area, or use a flash if necessary. Position the group so that they hold the baby up close to their face level, in order to keep the focus of the frame all in one area.

Step 3—Many times you end up with the adults looking at the camera and the baby looking away at something more interesting. Here's a fun way to take advantage of the situation: While someone else is getting a picture, slide around into a position where the baby is looking directly at you and the adults are all gazing off in a different direction.

Ingredients
- pumpkin patch
- Halloween outfit
- overcast day
- zoom lens

Step 1—Halloween is a great day—whether your little one is old enough for a costume or not. We settled for a baby in a sea of pumpkins. Choose a day that is overcast or go out late in the afternoon. This will make it easier on baby's eyes and create a softer image.

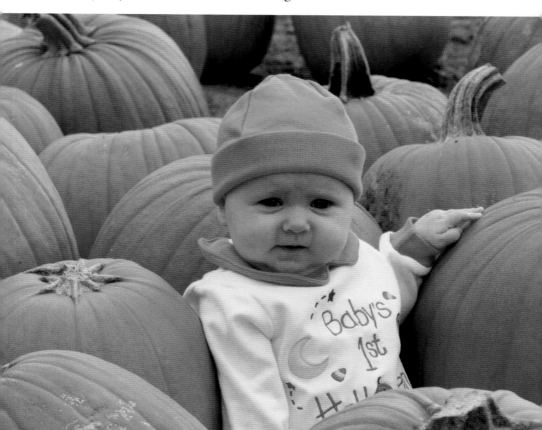

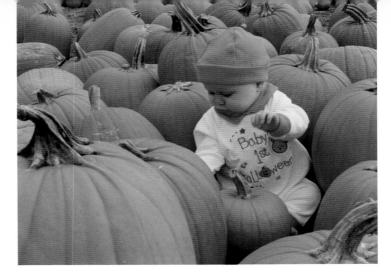

Step 2—Give baby some time to settle in. Hopefully her curiosity will be aroused and she will start to play and interact with the pumpkins.

Step 3—Remember to place some pumpkins between you and the baby to create a nice foreground in your photo. Get both wide views and close-up shots.

Tips

1. Choosing your baby's wardrobe for this type of photo is critical. Consider the overall color scheme of the scene—or maybe you are going for a specific theme or mood. This photo might have worked with baby in denim overalls and an earthtone shirt, or in a scarecrow or witch costume. If we had dressed her in a bright pink tutu it certainly would not be nearly as pleasant to look at.

2. With the wide angle lens, fill the frame with pumpkins.

★ CHRISTMAS

Ingredients

- baby in Santa hat
- holiday outfit
- icicle Christmas lights
- red cloth, green towels
- silver star pillow
- zoom lens (70—210mm)
- fast film
- window light
- bounce light

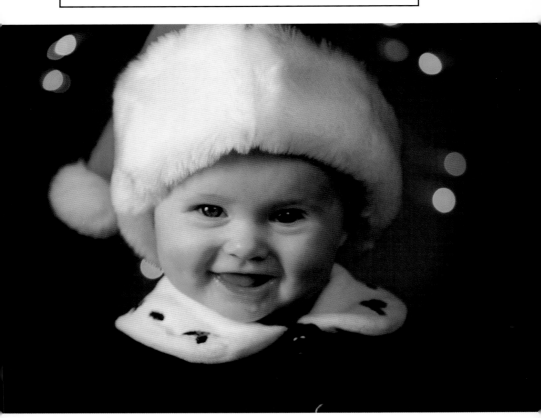

Step 1—It's November and you want to take a Christmas-card photo of your baby to share with relatives. First, find a room in your house with a good source of sunlight (see the lighting diagram below). Choose a back-drop, and gather your holiday props. I hung a red tablecloth on the clos-et doors and placed green towels on the floor. I dug out a strand of Christmas lights and some plush hol-iday toys from storage.

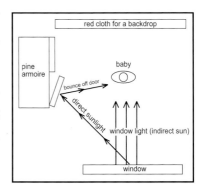

Step 2—Hang the Christmas lights (the small ones work best) across your backdrop. Set baby up about three to four feet in front of the backdrop.

Step 3—Use your zoom lens to take the pictures and zoom in as far as possible (this will vary depending on

how much space you have to work in). The shallow depth of field of the longer lens will cause the lights to blur and appear bigger, suggesting the presence of a Christmas tree or other holiday decorations in your home.

Step 4—This is the time, if you have resisted in the past, to absolutely take an entire roll. You want to have as many shots as possible from which to select the best image for your card. Also, consider shooting a roll of black & white film. Once you are set up, the majority of the work is done. Relax and shoot another roll.

Tips

1. With an elaborate setup, consider shooting both color and black & white photos.

2. It's helpful to have a second adult (or one of baby's siblings) to assist you in "wrangling" her. Due to the elaborate setup, you won't be able to move the camera off angle to the backdrop. Have your assistant move around the room and get baby's attention in order to get different expressions and angles on baby's face.

Ingredients
- holiday decorations
- holiday outfit
- flash when necessary

Step 1—Now that Christmas (or whatever winter holiday your family celebrates) is really here, the house, the mall, and the park are all decorated for the season. By Thanksgiving, outdoor holiday displays are usually beginning to appear. Grab the opportunity to use these ready-made scenes for backdrops to your photos.

Step 2—Outside, look for an area with shade or dappled sunlight (above). This will help to minimize harsh shadows and squinting eyes. Inside, use the flash if necessary. A direct flash creates a sharp, action-stopping photo (above left) while pointing the flash at the ceiling helps to preserve the warm ambience of the hearth scene (above right).

Step 3—Remember to always have an adult/sibling look at the camera at all times, and let you get the baby's attention. This way you only have to concentrate on the baby, counting on the fact that the other person in the photo is ready and smiling at the camera.

Tips

1. Take advantage of these days when family, friends, and baby are all dressed up for the holidays.

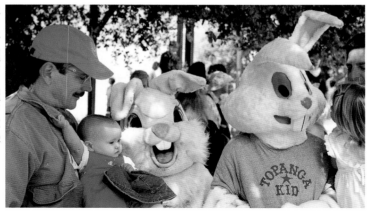

Photo by Whitney White McCleery.

★ EASTER—EVEN BUNNIES!

Ingredients
- baby in Easter dress
- egg hunt with bunnies
- flash when necessary

Step 1—Easter is another great dress-up holiday—and you might even have the opportunity to meet an Easter bunny or two. Take your camera to church and/or to the Easter egg hunt.

Step 2—Shoot a photo expressly to record the Easter dress-up clothes, as baby probably will only wear this outfit once. Get shots of baby meeting the Easter bunny, and try for pretty portraits of the family in their Sunday best, too.

Step 3—If the day is bright and sunny, look for a nice shady spot, perhaps under a tree (opposite). You may want to use your flash to augment the dappled sunlight (below). The faces will expose brighter than normal, helping them to jump out at the viewer.

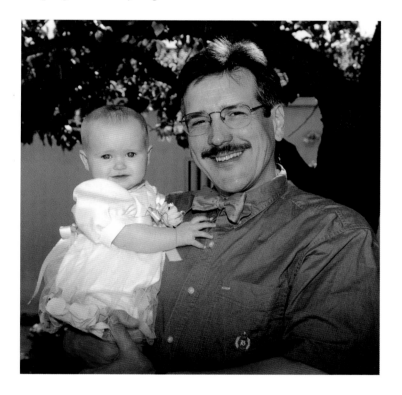

★ MOTHER'S DAY AND FATHER'S DAY

Ingredients
- baby and Mommy (or Daddy)
- the park
- fill flash

Step 1—Is it your first Mother's Day or Father's Day? Then it's time to get a portrait of you with your little one.

Step 2—This photo can be taken practically anywhere. I suggest you go somewhere where you feel relaxed. The resulting photos will be much more natural and reveal the "parent" in you, rather than a formal portrait, or a snapshot in a restaurant where you are worried about the potatoes your baby has just tossed on the floor.

Step 3—Try a posed photo first, and then go for a more photojournalistic look. See if you can capture her being "Mommy" or him being "Daddy."

Tips

1. The photo on the left (facing page) captures a sweet moment—Mommy helping baby just enough with that one finger.

2. The flash is more appropriate in the photo (facing page, right) where Mommy and baby are posing for the camera. In the photojournalistic style (facing page, left), the flash would have felt intrusive and broken the spell of the photo.

Ingredients
- birthday cake
- balloons
- family and friends
- flash

Step 1—At your baby's first birthday party, recruit some-one else to take photos. You have plenty to do without having to think about documenting the day.

Step 2—Make sure they know how the camera works, or have them use their own camera while you provide the film. There is no way to know what to expect. Some babies rip open their gifts with abandon, or smear cake all over their faces (and their friends). Some are more reserved, overwhelmed by the day and all the attention.

Tips

1. Watch for intimate moments where baby is alone or relating to others her age. It is easy to overlook the little things and only shoot the presents and the cake. You might even find the time to get a few of these shots yourself.

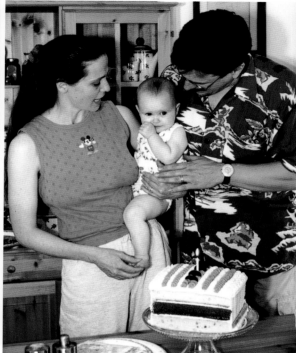

Step 3—Get what you can, and remember to tell your recruit to shoot a lot of pictures, assuring you'll end up with more good ones.

★ A YEAR IN THE MAKING . . .

Ingredients

- a plan
- photos taken at intervals (monthly)

Step 1—Babies grow so fast in their first year. In fact, on average, they triple their birth weight. This is a great time to record all the changes. Start planning early. It is easy to let the first month slip by when all you want to do is sleep.

Step 2—Decide whether you want head shots (as shown on the facing page), full-body shots, or a mixture. I chose close-ups, because during the first six months or so, there is very little movement on your baby's part. I also chose to keep the images as uniform as possible in order to emphasize the changes in the baby.

Step 3—Every month (don't panic if you are a week off in one direction or another), make sure you set aside a time to do these portraits. Sometimes you are lucky and the opportunity presents itself without much fuss. Simply be prepared—with your camera and your plan—to take advantage of any opportunities.

Ingredients
- baby at different ages (three or four times during the first year)
- prop to compare size
- flash

Step 1—Another fun grouping of photos can show how baby's size changes throughout the first year. Choose a favorite prop—maybe a plush animal that is about the same size as your newborn baby.

Step 2—Once every four months (preferably at birth, four months, eight months, and twelve months), take a photo of your baby and the selected prop. In the first photo, the prop will probably be laying next to baby. Then maybe she can lean on it. By the time the last photo is made, she could be carrying it or playing with it.

Step 3—Mount the several photos in a collage-type frame and watch baby grow before your eyes.

Ingredients
- baby's hands/feet
- Daddy's hands
- flash

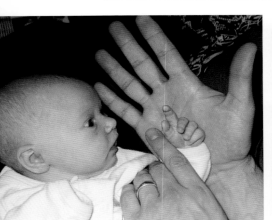

Step 1—Often, the most marveled-at parts of newborn babies are their hands and feet. They are so tiny, so perfect, and so soft. A photo memory of just how tiny and perfect they were will be quite precious when baby grows up into a teenager.

Step 2—Within baby's first month, shoot a close-up of baby's hand or foot laying against Mom or Dad's adult-sized hand.

1. When taking the second photo, get out the first photo and refer to it in order to re-create the original image as closely as possible.

Step 3—Near baby's first birthday, try to recreate the photo as closely as possible. You will be surprised at how much baby has grown.

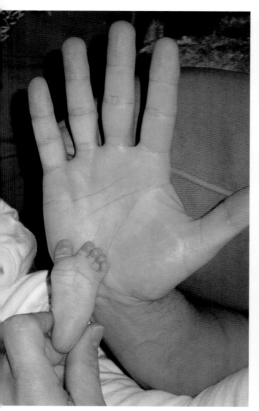
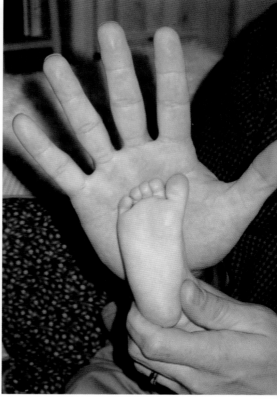

Ingredients
- baby in light clothes
- Daddy in dark clothes
- blanket at the park
- zoom lens (70–210mm)

Step 1—Remember, most of your baby's world is attached to you. Get photos and casual portraits of baby with Mom and Dad. We found that a park is a great place to get nice lighting and a calm atmosphere to shoot some intimate photos of the family.

Step 2—Get comfortable. Relax and play a bit before you start trying to capture the moment. A big shady tree is ideal for pretty light. (Be careful, some trees are close to the ground and so thick with dark leaves that their shade is too dark for useful photography.)

Step 3—You can either shoot posed portraits (previous page) or try to capture some natural interactions between baby and her parents (above and page 98). Shoot a whole roll—it'll be worth it.

Tips

1. Note how baby's head is always clearly visible, either against an out-of-focus background, the dark background of Daddy's shirt, or the dark background of the green grass.

★ SELF-PORTRAITS

Ingredients
- a camera you can operate with one hand
- wide-angle lens (24mm or 35mm)

Step 1—People often offer to shoot a photo of the family all together when we are out and about with our cameras, but we also like to take self-portraits. You can either set the camera on something (a bench, wall, rock, etc.) and use the self-timer, or use a small camera (point & shoot type) and hold it out in front of the group.

Step 2—It takes some practice to accurately aim the lens. If there are two adults in the photo, you can actually have one hold the camera and the other position it to frame all of you before he slides into the frame. Place baby between you and hold her head up close to the adult level.

Step 3—As you get more accurate, and depending on how wide your lens is, you might even try to include background elements in your photo.

Tips

1. The camera seems to get baby's attention all on its own. Baby looks at the camera because it is funny that Mom is holding it out in the air in front of you both. Note the reflection of Mom's arm in her glasses in the photo on the previous page.

Ingredients
- wedding dress, adult-sized clothing or costume
- window light

Step 1—Dressing up baby in Mom or Dad's grown-up clothes is always an adorable sight. Again, return to that perfect spot with great light in your house. Do this when baby is in a good mood.

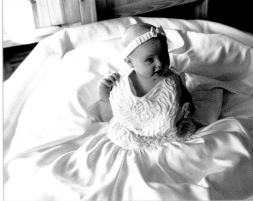

Step 2—I laid out the wedding dress on the floor and got my camera set up before I introduced baby to the scene. I then carefully set baby into the center of the dress and started shooting pictures.

Step 3—This could also be the first in a series that you continue until your child actually fits into the clothes.

Tips

1. This photo is most simply done when baby can sit up, but is not yet crawling.
2. If you can, shoot both color and black & white while you have everything set up. You don't want to do this twice.

Ingredients

- a setting conducive to photography
- window light
- zoom lens (70—210mm)

Step 1—As your child gets older, capturing a nice portrait becomes more of a race than a waiting game. New expressions disappear faster than they arrived. Your baby is now more aware of her environment and reacts to it.

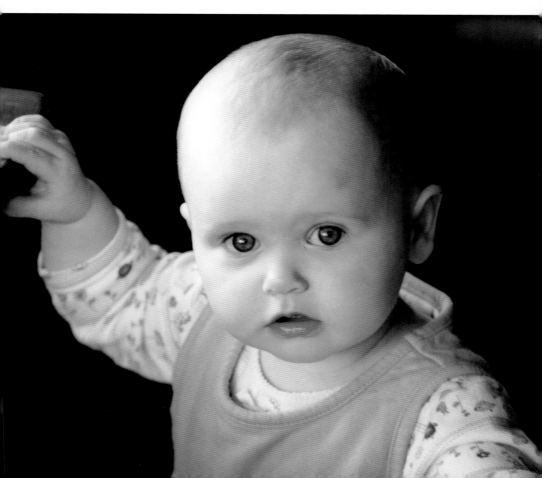

Try to keep a camera handy for those fortunate times when baby is playing in a spot with good natural lighting and is in an agreeable mood.

Step 2—Use a long lens, preferably 70mm or more, to isolate baby's face. As always, position yourself to find the best angle where baby's face is illuminated by a window or bounce light from outside, and her head is separated from the background. Separation can be enhanced by using a telephoto lens (the background will be out of focus), with light (the background is all much darker than baby's face, or much lighter), or with color (baby against a solid color that differs from her skin tone).

Step 3—Watch and wait for an expression that evokes the mood of the photo. An example is the photo on the previous page. This would not be as interesting a photo if she were smiling or laughing. The soft light with the dark background calls for a more somber look.

Tips

1. Composition is key. Move your camera to the best position for the shot. Watch out for distracting elements behind your subject—avoid objects that seem to be sticking out of people's heads, for instance.

Ingredients
- family and friends
- bench or couch that seats everyone

Step 1—Babies' moods and expressions change rapidly from happy, to coy, playful, curious, frustrated, cranky, or bored. A fun idea is to make a series—two, three, or four photos—as baby expresses herself or interacts with others in the scene.

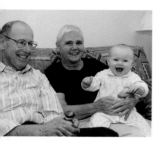 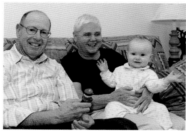

Step 2—Set up your family portrait. It is a good idea to dress everyone in similar tones (blue and white, above; red and blue, next page). Playfully shoot a series of photos. Let baby wriggle around and do whatever she wants—even change laps.

Step 3—You may have a dozen shots from which you can choose the best three or four to frame together.

Tips

1. This kind of presentation also makes everyone happy because there is usually at least one good photo of everyone in the group.

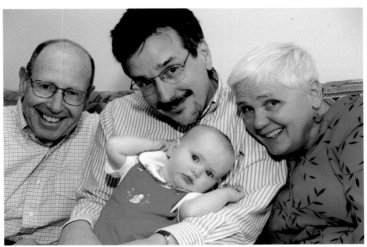

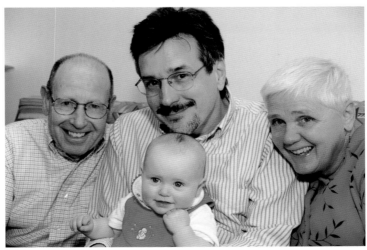

★ CAPTURING THE MOMENT

Ingredients

- energy
- patience
- camera nearby at all times
- natural light or flash

Step 1—This final recipe is just to remind you of the basic elements involved in taking great pictures of your baby:

1. Always have a camera with you.
2. Get to know how to operate your camera and flash.
3. Be aware of your baby's moods and use them to your advantage.
4. Watch for nice natural light and take advantage of the beauty that pops up unexpectedly.
5. Be patient with yourself and your baby.

Step 2—Be willing to take your camera out, patiently watch for a great photo, and possibly put it away without even shooting one image. That magic moment doesn't always happen. Watch for shots of baby interacting with other people, not necessarily just the camera. Anticipate. Watch for both playful moments and intimate ones.

Step 3—Remember that just because you are taking photos, it doesn't mean you have to stay outside of the action and all the fun. Take you and your camera into the middle of the action—that's where the good photos are waiting for you.

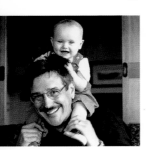 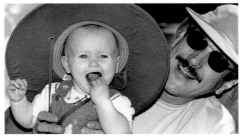

INDEX

OTHER BOOKS FROM
Amherst Media®

Picture-Taking for Moms & Dads
Ron Nichols

Anyone can push a button and take a picture. It takes more to create a portrait that will be treasured for years to come. With this book, moms and dads will learn how to achieve great results—with any camera! $12.95 list, 6x9, 80p, 50 photos, order no. 1717.

Basic 35mm Photo Guide, 5th Edition
Craig Alesse

Great for beginning photographers! Designed to teach 35mm basics step-by-step—completely illustrated. Features the latest cameras. Includes: 35mm automatic, semi-automatic cameras, camera handling, f-stops, shutter speeds, and more! $12.95 list, 9x8, 112p, 178 photos, order no. 1051.

How to Take Great Pet Pictures
Ron Nichols

From selecting film and equipment to delving into animal behavior, Nichols teaches all that beginners need to know to take well-composed, well-exposed photos of these "family members" that will be cherished for years. $14.95 list, 6x9, 80p, 40 full-color photos, order no. 1729.

Step-by-Step Digital Photography
A GUIDE FOR BEGINNERS
Jack and Sue Drafahl

Many so-called instructional manuals are so complex they scare new photographers away. This book provides the step-by-step approach beginners need to master everything from holding the camera, to basic exposure and flash photography, to cleaning and caring for your camera. $14.95 list, 9x6, 112p, 180 full-color photos, order no. 1763.

More Photo Books Are Available

Contact us for a FREE catalog:

AMHERST MEDIA, PO BOX 586, BUFFALO, NY 14226 USA

www.AmherstMedia.com

Ordering & Sales Information: *INDIVIDUALS:* If possible, purchase books from an Amherst Media retailer. Write to us for the dealer nearest you. To order direct, send a check or money order with a note listing the books you want and your shipping address; Visa and MasterCard are also accepted. For domestic and international shipping rates, please visit our web site or contact us at the numbers listed below. New York state residents add 8% sales tax. *DEALERS, DISTRIBUTORS & COLLEGES:* Write, call or fax to place orders. For price information, contact Amherst Media or an Amherst Media sales representative. Net 30 days.1(800)622-3278 or (716)874-4450, FAX: (716)874-4508

All prices, publication dates, and specifications are subject to change without notice.
Prices are in U.S. dollars. Payment in U.S. funds only.

hats for
baby